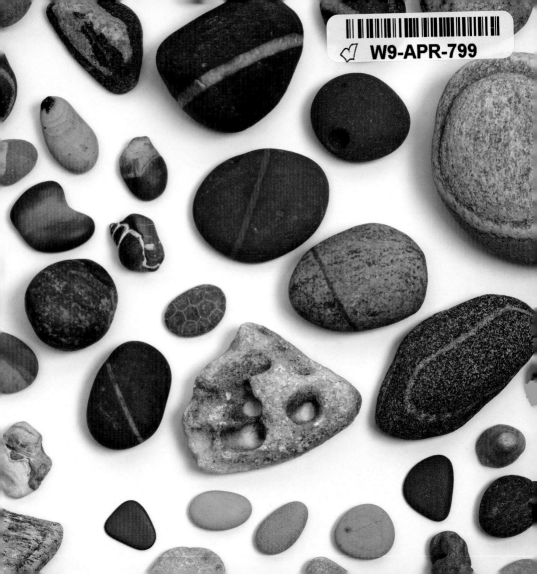

W9-APR-799

A Crazy
Little Series™

For Laurie

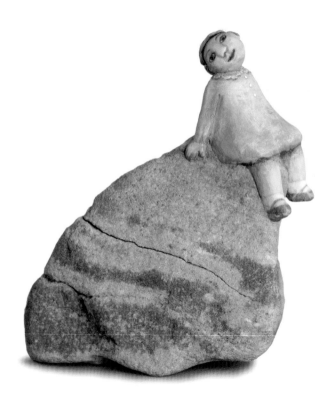

Stone Crazy

by
Tracy Gallup

Mackinac Island Press

for the love of reading

Once I read a poem that said

Go inside a stone.

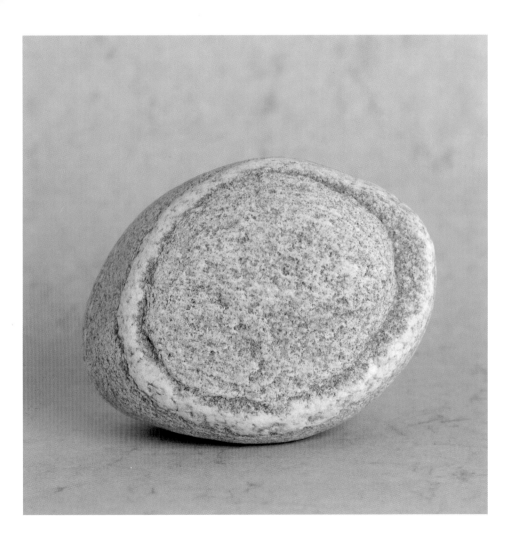

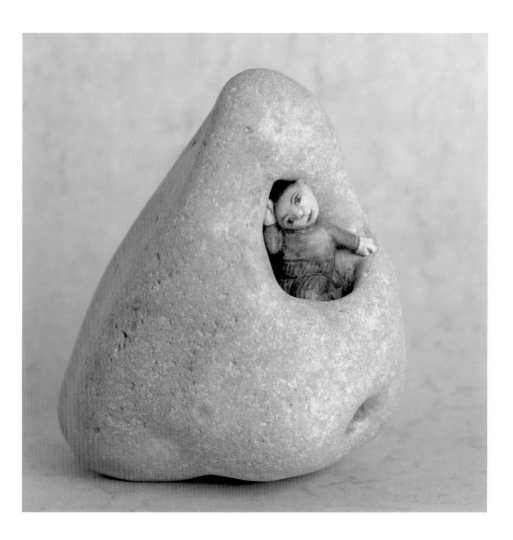

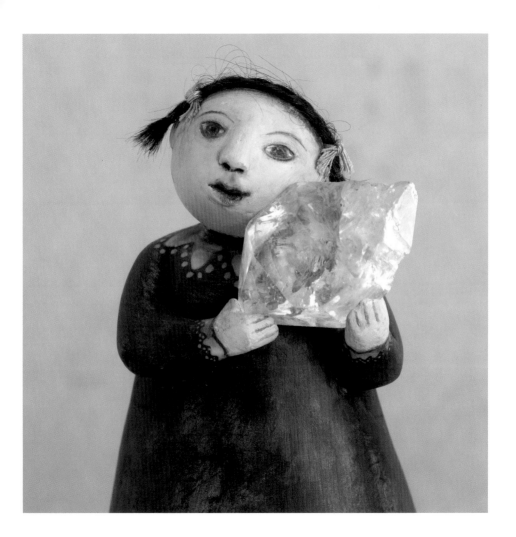

I like to wrap my arms around stones

to feel their warmth on sunny days.

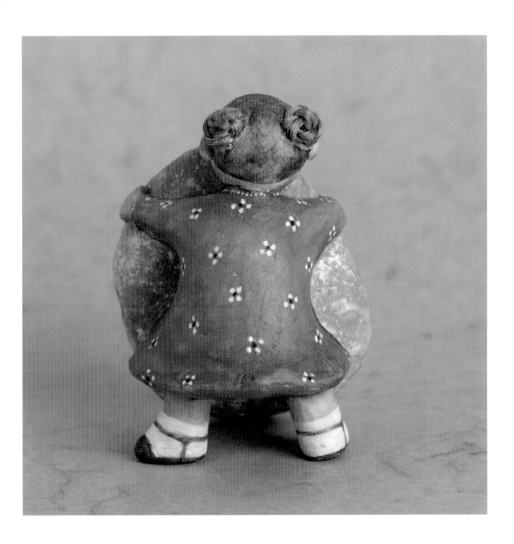

On a trip to the beach

we search for stones along the shore.

My friend finds an interesting one.

I say, "Save that.

You can make something with it."

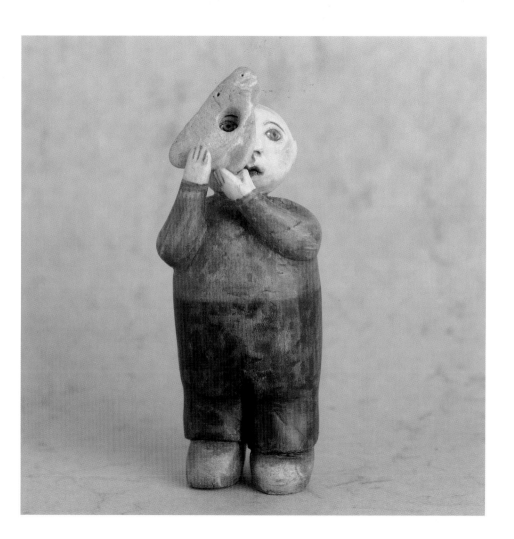

We spend hours looking for stones.

They are so heavy we can't

carry them all back,

so I hide a pile behind a big rock.

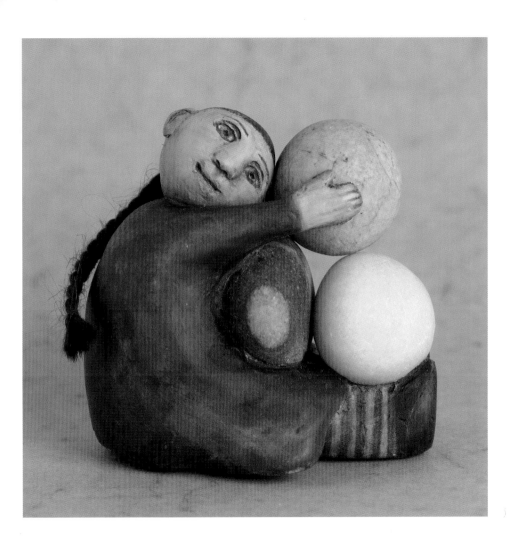

When we return, they are gone, and there are little footprints everywhere.

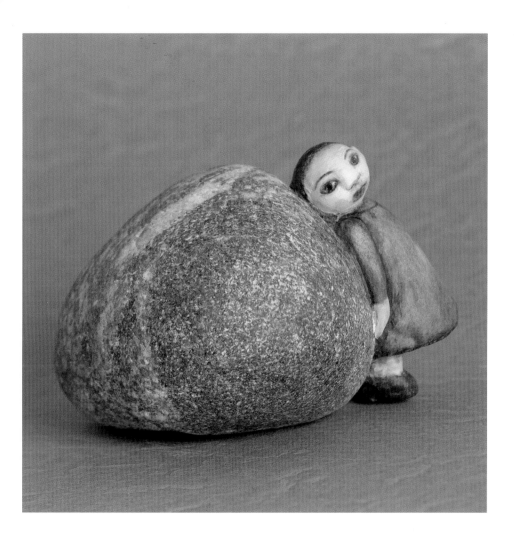

But what luck!

My stone that looks like a turtle

is still there.

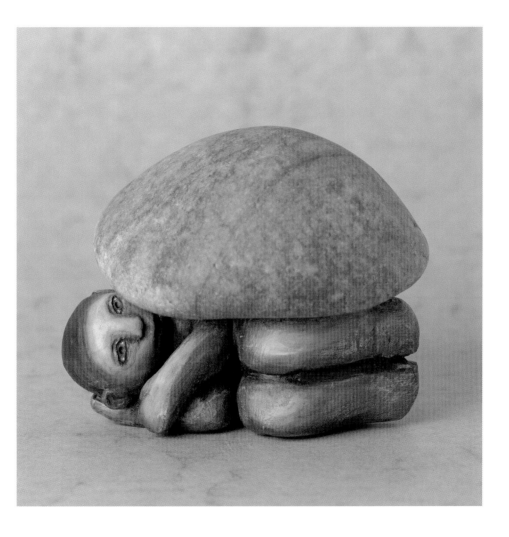

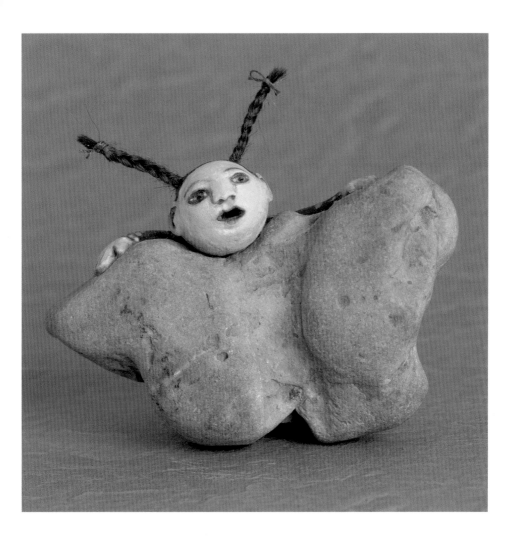

When I get home the stones inspire me.

This one seems heavy,

so I want to see if someone can hold it up.

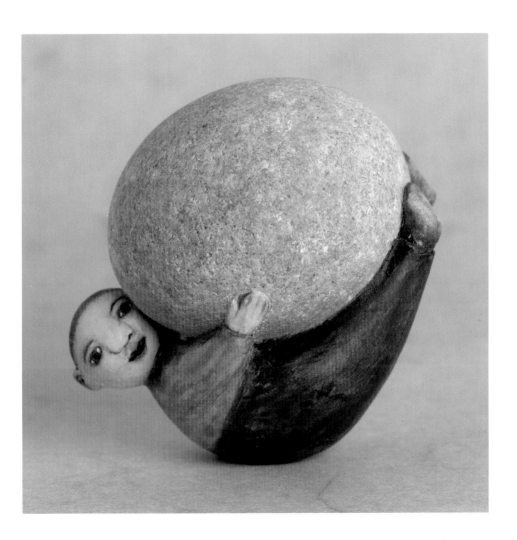

A little girl comes along

to keep this bird stone warm.

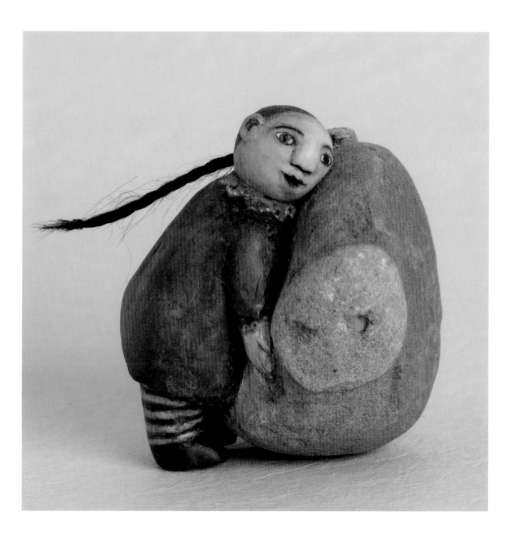

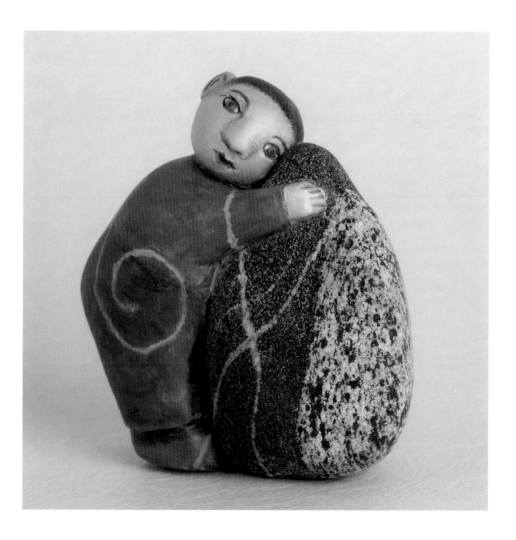

The stones tell me what to do.

They say,

lean on me,

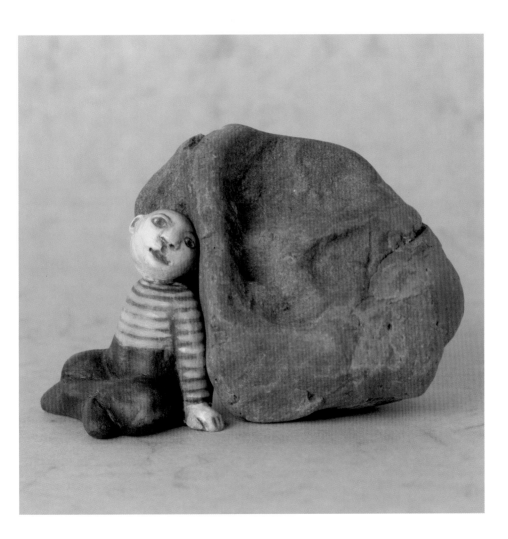

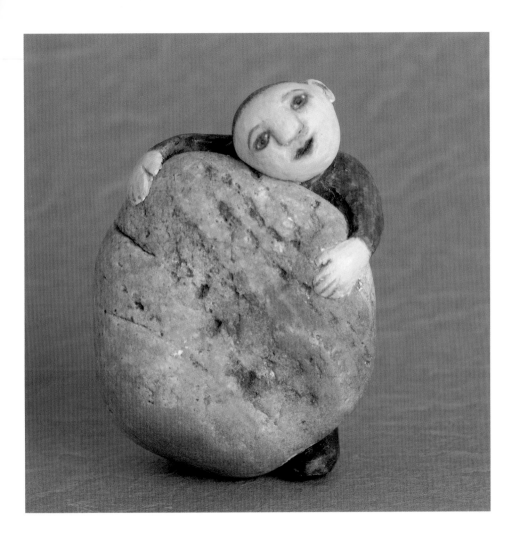

climb up,

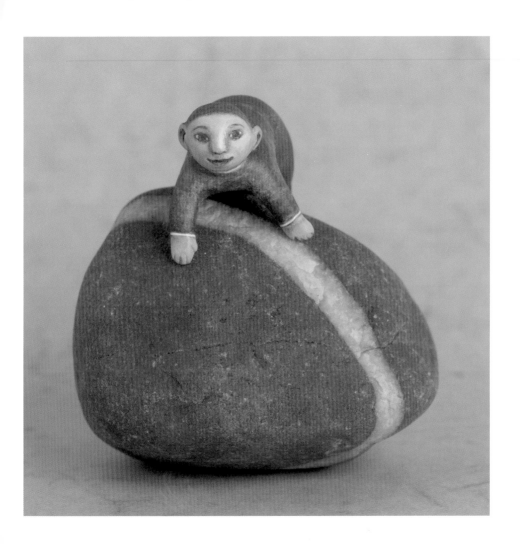

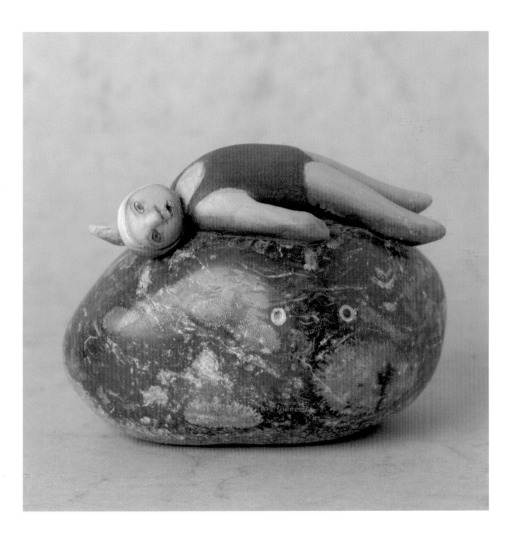

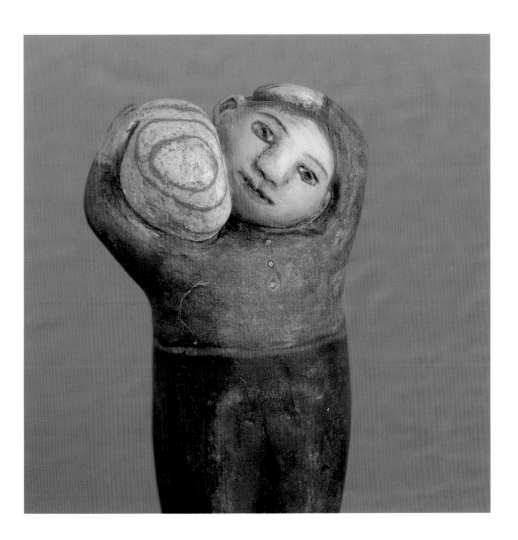

I listen.

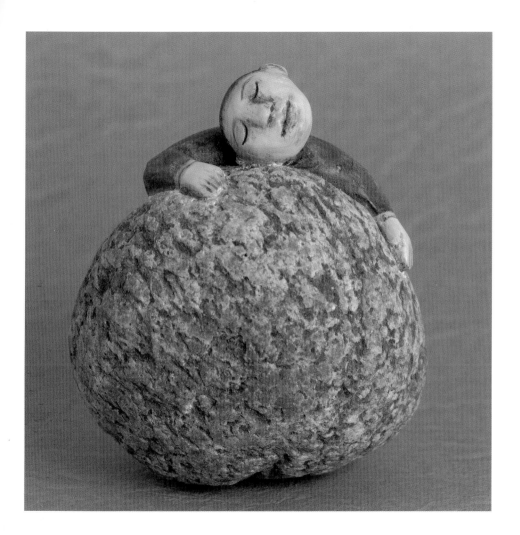

Library of Congress
Cataloging-in-Publication Data on file

Tracy Gallup
A Crazy Little Series™: *Stone Crazy*

ISBN 978-1-934133-13-2
Fiction

10 9 8 7 6 5 4 3 2 1

A Mackinac Island Press, Inc. publication
www.mackinacislandpress.com

Mackinac Island Press
for the love of reading

Printed in China

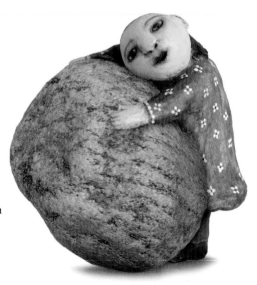